DISTANT ECHOES:
PAINTED RELIEFS AND
DRAWINGS BY
MIGUEL ZAPATA

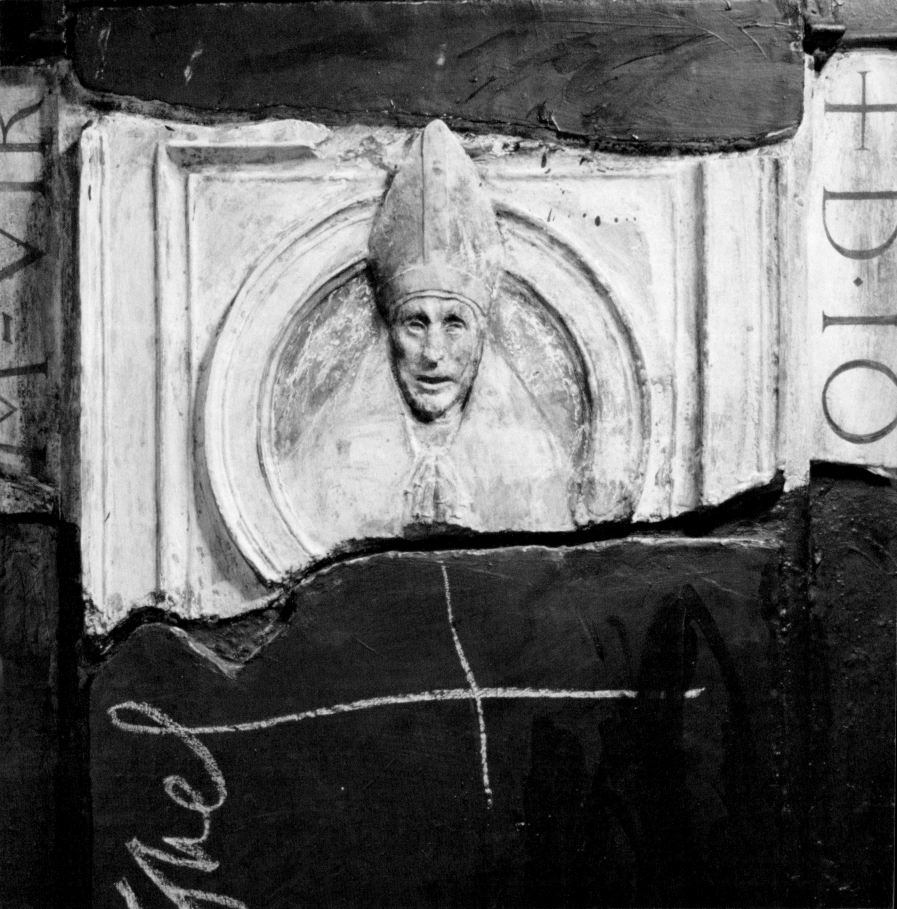

DISTANT ECHOES:
PAINTED RELIEFS AND DRAWINGS
BY MIGUEL ZAPATA

Introductory Essay and Interview by
Marcus Burke

MEADOWS MUSEUM
SOUTHERN METHODIST UNIVERSITY
DALLAS, TEXAS

Copyright © 1986 by the Meadows Museum,
Southern Methodist University, Dallas, Texas.

Library of Congress catalogue card number
86-062683

ISBN 0-935937-02-1

The exhibition was held at the Meadows Museum,
Owen Fine Arts Center, Southern Methodist University,
November 6 through December 28, 1986.

Meadows Museum Staff:

Donald E. Knaub, Director

Marcus B. Burke, Ph.D., Chief Curator
JoAnn Cullum, Registrar
Anne Henderson, Curator of Education
Marilyn Spencer, Administrative Assistant
Lawrence Waung, Exhibition Designer

Photograph credits:

Alinari-Scala-Art Resource, figures 11, 43, 45, 47; Boston
Museum of Fine Arts, figure 26; Archivo Mas, Barcelona,
figures 9, 25, 30, 49; Museo del Prado, Madrid, figure 37;
Fundación Juan March, Madrid, figure 1; M. Burke, figures
6, 15, 16, 21 39, 48, 50-54; all others courtesy of Miguel Zapata
or Del Valle/Tapia.

Designed by James A. Ledbetter
Edited by Betsey McDougall
Printed at Hurst Printing Company, Dallas

Front cover:
Untitled (Cardinal), after Raphael, 1986 (040–86);
exhibition checklist number 37 (detail).

Back cover:
Untitled, after the Knights' Portal, Cuenca
Cathedral (ascribed to Antonio Flores), 1984;
exhibition checklist numbers 19 and 20.

Frontispiece:
Figure 36. Untitled, checklist number 42, 1986 (053–86) detail.

Opposite the foreword:
Figure 40. Untitled, checklist number 36, 1984 (037), detail.

CONTENTS

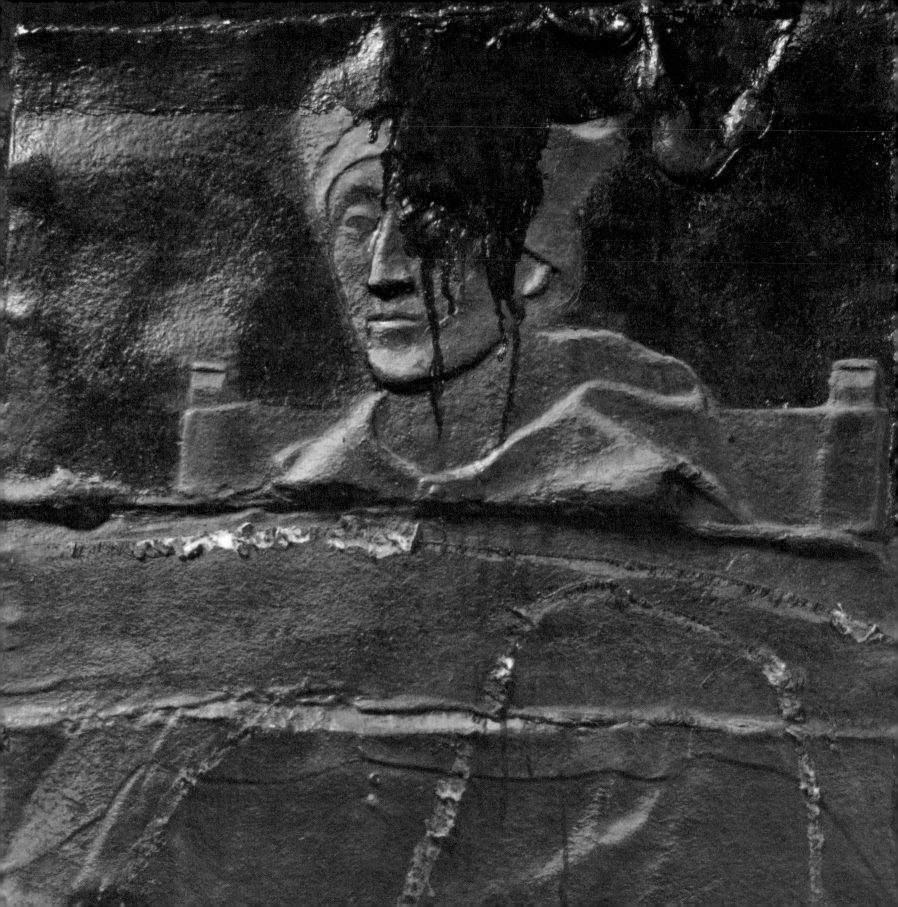

The Meadows Museum is pleased to present the first in what we hope will be a series of annual exhibitions that feature contemporary Spanish artists. Miguel Zapata seems the right choice for this first exhibition because he bridges in imagery the Golden Age of Spanish art with the second half of the twentieth century. We anticipate that Zapata's work will lead the Museum into an exploration of the art of the twentieth century in Spain, as a natural outgrowth of our concentration of fifteenth through early twentieth-century Spanish paintings.

Among the many people who assisted in the formulation of this exhibition, we owe a special debt to Ms. Irene Martín, director of the Fundación Xavier Corberó in Barcelona, Spain, and previously interim director at the Meadows Museum, for her initial contact regarding the potential for a Meadows exhibition.

Spanish logistical arrangements were made through the Del Valle/Tapia Agency in Madrid, which represents Zapata's work. Begoña del Valle and José Antonio García Tapia, principals in this agency, are very closely associated with Zapata and have made working on this project a pleasant and enjoyable experience. We have also enjoyed the cooperation of Edward Caraco and his colleagues at Adams-Middleton Gallery, Dallas.

We are particularly grateful to the Ministry of Culture of the Spanish government, which provided a grant underwriting the preparation and transportation of the works of art. The Ministry's generous intervention, along with the program support provided by Dr. Eugene Bonelli, dean of the Meadows School of the Arts, has made this exhibition possible.

Donald E. Knaub, Director

DISTANT ECHOES: PAINTED RELIEFS AND DRAWINGS BY MIGUEL ZAPATA

Miguel Zapata was born in the Spanish city of Cuenca in 1940. His mother was of Basque origin and his father a banker from a prominent Madrid family. Zapata attended public schools in Cuenca, growing up literally in the shadow of the cathedral and participating in the religious processions that are such a marked part of Cuencan life.

Zapata's artistic talent manifested itself at an early age; he was constantly drawing and creating works of art, encouraged and inspired in part by a creative if eccentric uncle from Madrid. Zapata's father, however, whose own father had been a famous lawyer, sought a legal career for his son, and Miguel was enrolled at the Faculty of Law of the University of Madrid in 1957. Although his classmates included many who would play important political roles in the coming decades, including the present king, Juan Carlos, Zapata was not attracted to his studies, preferring instead to continue developing his art.

In early 1958, at the age of seventeen, Zapata submitted a portfolio of drawings to a competition for a commission to decorate the parish church of La Merced in the small town of Huete. Selected on the basis of these drawings (he had recently won another prize in the Sesamo artistic competition), Zapata was called to Huete to begin painting the church. Despite misgivings about his age and experience, Zapata was given the task, which he carried out to mixed reviews. Like the young Goya, whose religious cycles were often too avant-garde for prevailing clerical tastes, Zapata found his artistic honesty at odds with the prevailing rural aesthetics. He preferred, for example, to use local construction workers as his models for the angels on the ceiling of the church, instead of the idealized types desired by his patron. Work was interrupted by the parish priest's refusal to pay Zapata's wages, thus precipitating a severe financial crisis in the young artist's life. The ensuing series of altercations between Zapata and the priest, along with Zapata's failure to present himself for final examinations at the faculty of law, led to a break with his father and the beginning of a period as an independent artist in Madrid.

The next several years found Zapata

Figure 1. Manuel Millares (1926–1972), *Antropofauna*, 1970; Fundación Juan March, Madrid.

working at odd jobs and as a portraitist in Madrid taverns, as well as preparing more serious easel pieces in an expressive figural style for exhibitions. A successful presentation in San Sebastian led to a portrait commission and a brief residency there during 1960. Zapata subsequently moved to Barcelona, living with a group of artists, including the Cuban-born American, Eugenio Kuriakin. Zapata continued to exhibit in Barcelona, Salamanca, Bilbao, and Madrid.

Spain in the early 1960s was emerging from twenty years of cultural isolation enforced by Francisco Franco's fascism. The dominant artistic style was the semiexpressionist manner — often expressed in landscape, portraiture, and other noncontroversial genres — of the School of Madrid. In contrast, a younger generation of artists began in the 1950s to explore the abstract styles dominating art in the rest of Europe and the United States. Antoni Tàpies and other members of the Dau-al-Set group in Barcelona (named for a magazine founded in 1948) and the more gestural El Paso group, founded in Madrid in 1957 by Antonio Saura, Manuel Millares, and Luis Feito, among others, took the lead in promulgating the new art, generating a Spanish equivalent to American abstract expressionism.

Tàpies' and Millares' (figure 1) works emphasized textural manipulations such as those found in André Masson's surrealist paintings of the 1920s and 1930s and contemporary abstract surreal works by Jean Dubuffet and other members of the *Art Informel* group in France or by Alberto Burri in Italy. (Burri seems to have had a particularly strong influence on his younger Spanish contemporaries.) Saura, on the other hand, developed a style filled with slashing gestures that are often compared to similar forms in the works of Franz Kline. Feito's nonfigurative biomorphic imagery was expressed in thick layers of heavy pigment, as though Hans Hoffman had reworked motifs from the compositions of the dadaist and abstract surrealist Hans-Jean Arp. Miguel Zapata has acknowledged the influence of all these older artists, especially Millares, in the formation of his own style (see the comments on the importance of the School of Cuenca, below).

6

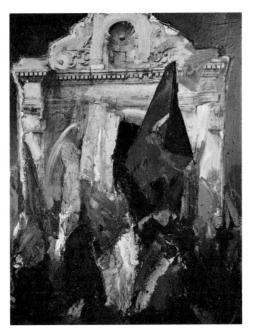

Figure 2. Untitled, checklist number 2, 1975 (001–75).

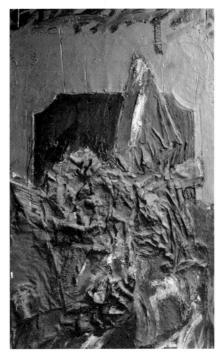

Figure 3. Untitled, checklist number 5, 1976 (006–76).

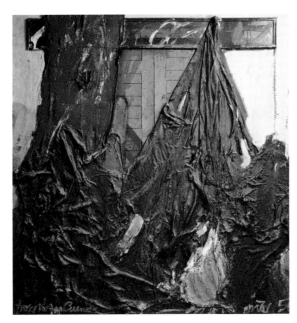

Figure 4. Untitled, checklist number 6, 1975–78 (009–78).

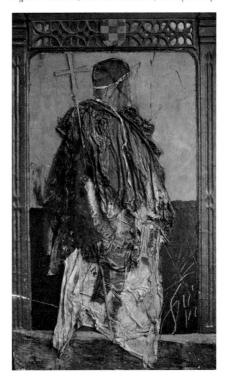

Figure 5. Untitled, checklist number 8, 1978 (007–78).

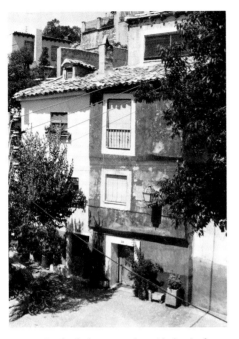

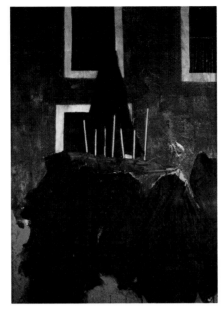

Figure 7. Untitled, checklist number 7, 1978 (015–78).

Figure 6. Facade of a house near the parish church of San Miguel, Cuenca (view taken from Miguel Zapata's window).

In 1964, Zapata moved to Paris, thus beginning a prolonged hiatus in his career as a painter-sculptor. He worked in the theater, designing sets and costumes for the Spanish-language theatrical group, La Carraca, and participating in government-sponsored theatrical tours. He was also a construction worker, taught Spanish, and took other nonartistic jobs. During this period, he continued his studies in the humanities and participated in the Parisian left-wing intellectual world, especially that surrounding Spanish political exiles.

Zapata's return to Spain in late 1967 was accompanied by personal problems. His family had moved from Cuenca to Madrid, but Zapata found that the conflict of values which had led to his adolescent rebellion made it impossible for him to remain as an adult in his parent's house. Fortunately, his friend Antonio Requena, a physician with an interest in painting, offered Zapata lodging in exchange for works of art. This not only had the effect of reviving Zapata's artistic career, but also sparked an interest in medicine. (Zapata recalls having also been influenced by a line from Boris Pasternak's *Dr. Zhivago*: "I need to dedicate myself to something universally useful.")

Zapata's career in medical school began successfully. His skills as a draughtsman were extremely useful to the professor of anatomy, and he also assisted his friend in his medical practice. He continued drawing and painting to pay the rent. His radical political involvement, however, drew him to clandestine meetings and other activities forbidden in the waning years of Franco's régime, leading to his interrogation and eventual expulsion from the university.

Fortunately, the Spanish art world had advanced tremendously in the years Zapata was away. In particular, Zapata's native city of Cuenca had become a center of abstract art. Even before Zapata left Spain, artists such as Saura and Millares, seeking a freer artistic climate than they found in Madrid, had established studios in Cuenca. In 1966, the abstract surrealist Fernando Zobel de Ayala, in collaboration with other Spanish abstract artists, opened the Museum of Spanish Abstract Art in Cuenca's Hanging Houses (*casas colgadas*).

In 1972, Zapata returned to Cuenca,

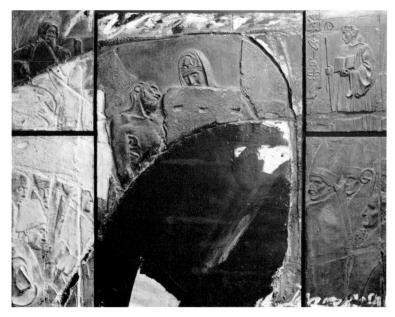

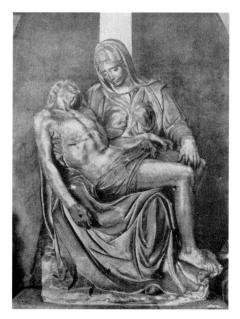

Figure 8. Untitled, checklist number 10, 1982 (016–82).

Figure 9. Juan Bautista Vázquez (Spanish, XVI Century), after Michelangelo, *Pieta*, Avila Cathedral (marble).

buying a house, which, like many houses in the old part of Cuenca, was literally piled on top of another, in this case the house where Millares lived. (Although Millares died soon after Zapata's return to Cuenca, the older artist's widow and daughter continued to live below Zapata.) He met with relative success as a portraitist, while developing the procession images that would initiate his mature style (figures 2, 3, 4 and 7). He presented an exhibition at Cuenca in 1979; a second exhibition later that year at the prestigious Juana Mordó Gallery in Madrid (only a few hours' drive from Cuenca) gave further impetus to his career. Zapata's interest in architecture also found expression in his involvement with the Faculty of Architecture at the University of Madrid.

Zapata continued to exhibit in the period 1981–83, working in Madrid, which is today his principal residence, as well as Cuenca. His compositions became increasingly sculptural, increasingly concerned with architectural elements. In effect, Zapata inverted the artistic values of his procession series and related figure pieces: instead of expressionistic manipulations of abstract elements creating figural images, Zapata's works began to present figural elements directly, overlaying them with abstract gesture. (A comparison of figures 5 and 7, with later works such as those illustrated in figures 8, 10, or 32, reveals how striking the change had been.)

The critical success of six exhibitions in 1984 and 1985 cemented Zapata's reputation as one of the leading artists in contemporary Spain. The increase in cultural activity that marked Spanish life in the decade following Franco's death, and which has recently sparked the so-called *movida*, or cultural ferment celebrated in the international press, has also prepared a way for the reception of Zapata's works among critics and on the art market. Most recently, Zapata's works were chosen for a travelling one-person exhibit sponsored by the government of the new autonomous region (*Comunidad*) of Castilla–La Mancha, which includes the province of Cuenca.

The Meadows Museum exhibition presents works from two periods in Zapata's recent career, as well as works which indicate the beginning of a new

Figure 10. Untitled, checklist number 11, 1983/85 (017).

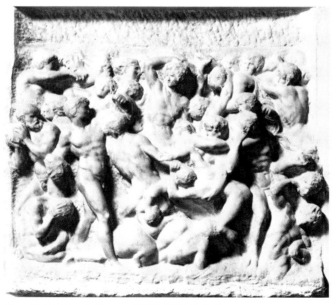

Figure 11. Michelangelo Buonarroti (1475–1564), *Battle of the Lapiths and Centaurs*, 1492; Florence: Casa Buonarroti (marble relief).

Figure 12. Untitled, checklist number 12, 1980–83 (014–83).

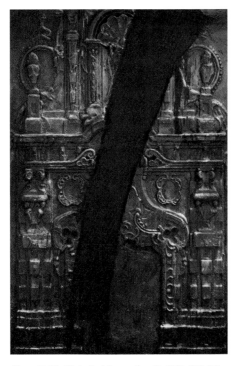

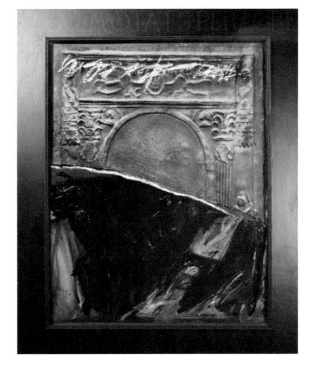

Figure 13. Untitled, checklist number 13, 1983 (012–83).

Figure 14. Untitled, checklist number 14, 1983–84 (021).

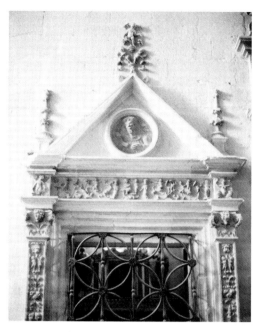

Figure 15. Lateral window, Chapel of the Apostles (XVI Century), Cuenca Cathedral.

Figure 16. Drawing after the Lateral window of the Chapel of the Apostles, Cuenca Cathedral (not in exhibition).

cycle. First is the period from 1972 to 1979, in which Zapata, recently returned to Cuenca, developed compositions where manipulations of painted cloth strips and rags create abstract evocations of religious processions and other traditional Spanish themes, set against realistic architectural backgrounds (checklist numbers 1 through 9, figures 2–7, above). The architecture is not simply a backdrop; it plays an essential role in creating the illusion of human figures out of the abstract forms of the cloth (see the "Conversation with Miguel Zapata," below, p. 36). According to Zapata, he realized that the images of processions found better resonance in front of architectural elements — that once the figure he was working on was placed in front of an arch or doorway, it became

recognizably human. (That is, the *gestalt* of the human figure in his works was best supported by a ground of architectural forms.)

In many works of this series, the architecture begins to take on new importance as a thing in itself — for example, it begins to be expressed in three dimensions instead of two (figure 5). The gestural elements of the cloth strips and vibrant paint are increasingly subordinated to the general image in its architectural framework. By the early 1980s, Zapata had entered a second period, in which, as has been mentioned, gestural forms were used not to create images but to attack relatively faithful recreations of Renaissance monuments, including architectural fragments, reliefs, sculpted tombs, and other

statues (checklist numbers 10–18, 25–26, 29–34, 35–36; see figures 8–20, 27–28, 31–35, 38–40).

The latest works in this series suggest that Zapata may be moving on to yet another mode. The surfaces have become simpler, more classical, and the use of color more generalized, less expressionistic (for example, see checklist numbers 19–21, illustrated on the back cover; checklist 27; checklist 28, figure 29; and checklist 37, figure 41 and front cover), although Zapata is still creating his more gestural works, with their complex structure and deep sculptural form (checklist 42, figure 36).

When we first encounter one of Zapata's recent works — for example,

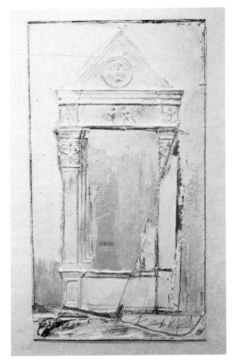

Figure 17. Untitled, checklist number 15, 1982 (052–82).

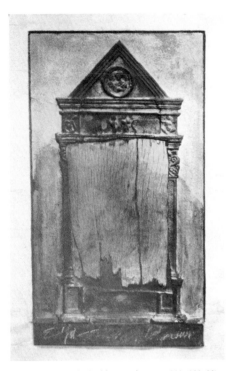

Figure 18. Untitled, checklist number 16, 1983 (030–83).

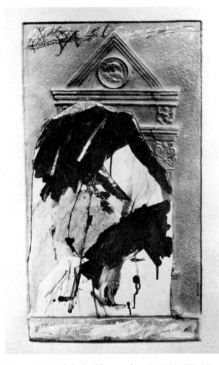

Figure 19. Untitled, checklist number 17, 1984 (028–84).

one of his variations on El Greco's *Portrait of Paravicino* (checklist 25 through 28, figures 26–29) — we are first drawn to the Renaissance image that has been so lovingly recreated. But our appreciation of this image is jarred almost immediately by the gestural strokes that divide, invade, cover, or otherwise attack the original image. The tremendously painterly quality of Zapata's large gestures is so compelling that we are left vividly aware of the artist's actions in creating the work: hence the term, originally applied to abstract expressionism, "action painting."

The effect of Zapata's manipulation of texture is more subtle but perhaps equally important. Indeed, one could characterize variations in his formal approach over the last ten years in terms of changing relationships between the presented image and the texture of the painted work. In Zapata's procession series, textural manipulations create the image; in the works of the earlier 1980s, texture is used over the entire work as a perceptual massage in the abstract surreal manner. In the artist's very latest works, texture is used in a more limited, controlled, and condensed way, while the color, as we have noted, has spread out into a uniform coating.

One consequence of Zapata's extensive and relatively faithful quotation of earlier masterpieces is that much of the original content of each piece can be apportioned along with the image. Thus, the viewer receives much of Raphael, El Greco, or Renaissance Spain — and of the artistic and philosophical values that informed the Renaissance as a whole. The Renaissance architecture that Zapata uses often has an inherent relationship with the human figure, especially when the architecture is part of a funerary monument with figural sculptures. Zapata's works reflect this sense of humanism.

This is not to say that Zapata merely reproduces the Renaissance monuments which serve as his sources. The face on most of the figures in the Paravicino series (figures 28–29, but compare figure 27) is not the face in El Greco's original (figure 26). A bishop's funeral portrait (figure 36) may take on the face of Donatello's *Zuccone* (Florence Cathedral; not illustrated). Zapata's sense of the play between two- and three-dimensional objects also removes his creations from their sources.

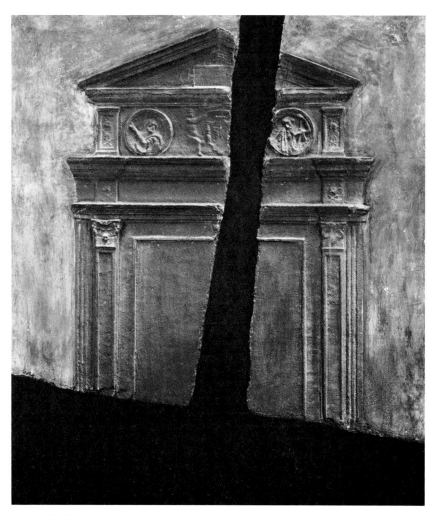

Figure 20. Untitled, checklist number 18, 1983 (013–83).

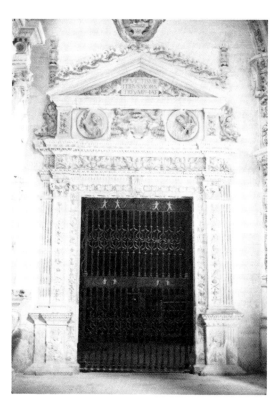

Figure 21. Ascribed to Antonio Flores (Spanish, XVI Century), Entrance Portal to the Knights' Chapel (Capilla de los Albornoces), Cuenca Cathedral.

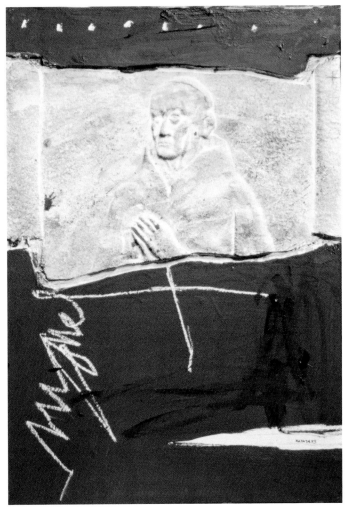

Figure 22. Untitled, checklist number 38, 1985 (067–85).

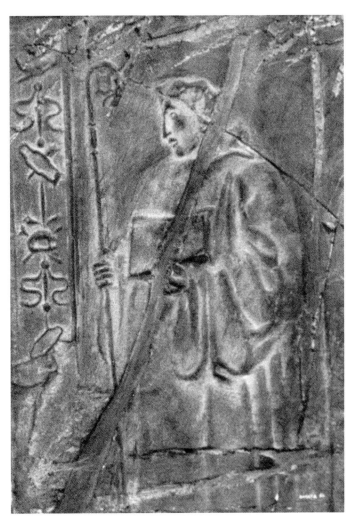

Figure 23. Untitled, checklist number 39, 1986 (025–86).

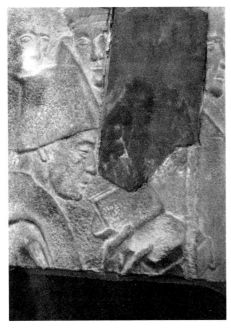

Figure 24. Untitled, checklist number 40, 1986 (054–86).

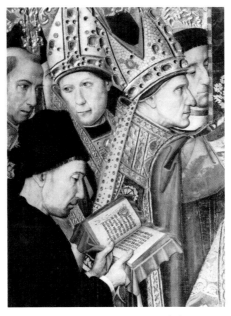

Figure 25. Jaime Huguet (1414–87), detail of *The Coronation of St. Augustine*; Museo de Arte Catalán, Barcelona (oil and tempera on panel).

El Greco's or Raphael's paintings become reliefs (figures 26–29, 37–41), while Donatello's or Verrocchio's sculptures become drawings, and Uccello and Castagno's frescoes pass through a series of dimensional variations (figures 42–47). Drawing and modeling play prime roles in this aspect of Zapata's art, liberating his style from a formal dependence on photography, although he uses photographs and printed reproductions, as well as drawings after the original works, as a means of remembering motifs. Of course, the gestural attacks or fragmentation of the original images also serves to remove his art from that of a mechanical copyist, and to set the original sources in a new and distinctly modern context.

Zapata's working methods also suggest the humanistic basis of his art. As we have seen, he often draws, and uses drawing to record and absorb motifs from the Renaissance monuments to which he is so passionately attached. In many cases, these drawings serve as the basis for two-dimensional works, including other drawings done on a large scale. Or Zapata may choose to work directly in three dimensions: a sculptural image such as the *doncel* from Siguenza Cathedral (figure 49) may pass through several variations, in several media, such as the as yet incomplete relief panel illustrated here (figure 50). Once the model is brought to the requisite finish, it can serve as the prototype for a series of molds used to form large sheets of heavy paper, which are subsequently hardened with acrylic medium. The hardened paper reliefs can then form the base for the artist's abstract compositions. The use of molds to produce multiple variants is not new; Zapata shares the technique with, among others in the Renaissance, Donatello and the Della Robbia family.

At least since the Dada movement, modern artists have relied upon extensive quotations from the history of art to provide extra layers of meaning in their works. Especially after the emergence of Pop Art in the late 1950s — and with the greatly increased role that art history and art museums have had in public education since World War II — artists have mined the masterworks of the past for images to set in new contexts. Curiously,

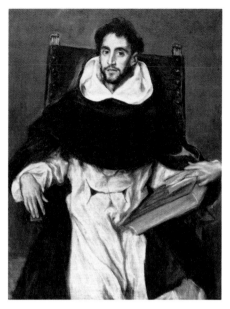

Figure 26. El Greco (Domenikos Theotokopoulos, 1547–1614), *Fray Félix Hortensio Paravicino*, 1609; Boston Museum of Fine Arts (oil on canvas).

Figure 27. Untitled, checklist number 25, 1983 (038–83).

Zapata seems to rely less on his viewers' art historical training than on their general awareness of what the Renaissance was and especially, what it meant for Spain. This is in keeping with Zapata's nonspecific attitude toward his Renaissance sources (see the "Conversation," page 33) and it serves to widen the appeal of his art.

In general, however, modernist practice has modulated, distorted, dissociated, or reassembled images from previous art (see Zapata's comments on Francis Bacon, page 34 below), and produced works that call attention to the process of these operations. Zapata, on the other hand, and especially in the works of the early 1980s, presents his versions of Renaissance monuments directly. In many cases, he has transformed the originals with regard to

physiognomy and two- or three-dimensionality, but this transformation is a prior event not recorded within the work of art itself. The effects of his gestural, "action painting" attacks are preserved *on* the fabric of the Renaissance image, just as if the image were in fact hundreds of years old. Hence, the ruined state in which Zapata's gestural attacks leave his versions of older works may be understood as a metaphor for the decay of time — for the damages which many Renaissance works, especially in Spain, have suffered over the years. Indeed, there is a nostalgic quality of lost time in many of Zapata's images that might connect them to the works of de Chirico were it not for Zapata's insistence on the actuality of his revivals.

Zapata's works participate in several

other important traditions of twentieth-century art. His emphasis on the media in which he works has long precedence, as does his manipulation of texture for psychological effect. Gesture was confirmed at the center of modern art by the abstract expressionists, but it had been established long before by the expressionists active in the late nineteenth and early twentieth centuries. Similarly, colorism and the use of mixed media have often been important aspects of modern practice. In terms of content, Zapata's works leave open the possibility of apocalyptic, or post-apocalyptic, interpretations, of the impending ruin of civilization and the hollowness of Western materialism, all keynotes of twentieth-century art.

Zapata's work exhibits several salient

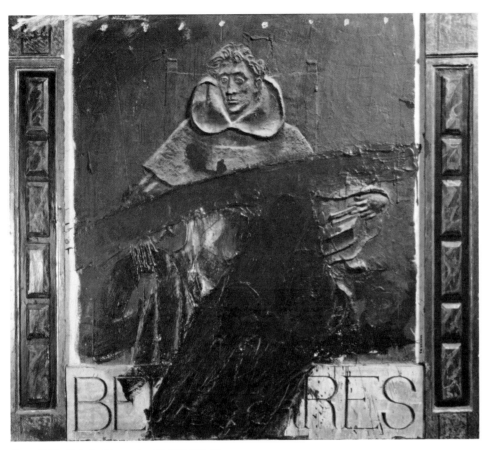

Figure 28. Untitled, checklist number 26, 1983 (011–83).

Figure 29. Untitled, checklist number 28, 1985 (020–85).

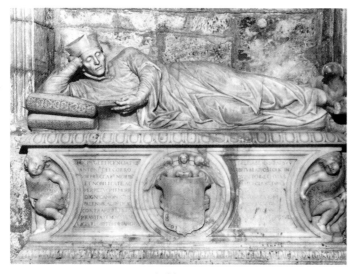

Figure 30. Juan Bautista Vázquez, *Tomb of the Inquisitor Antonio Corro*; parish church of San Vicente de la Barquera, Santander (marble).

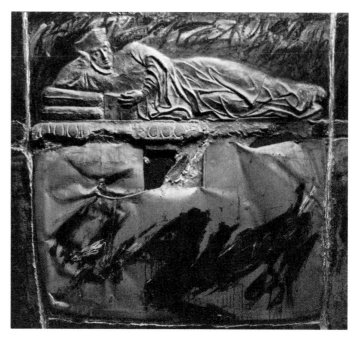

Figure 31. Untitled, checklist number 29, 1983 (056).

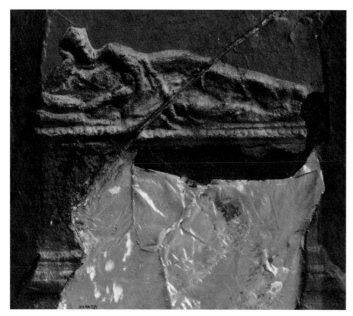

Figure 32. Untitled, checklist number 31, 1981/83 (039–83).

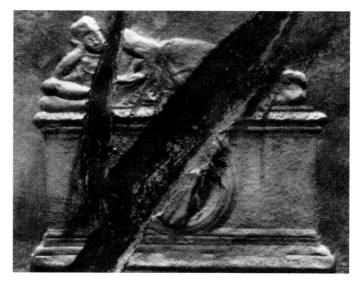

Figure 33. Untitled, checklist number 32, 1984 (064).

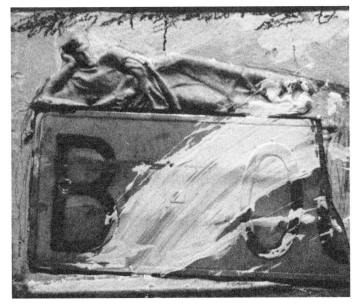

Figure 34. Untitled, checklist number 33, 1984 (044–84).

Figure 35. Untitled, checklist number 34, 1984 (036–84).

characteristics of the postwar Spanish school. His emphasis on media and especially on texture (*pintura matérica*) is a common aspect of contemporary Spanish art, established above all in the art of Tàpies. His works also owe a debt to the artists who preceded him in Cuenca, although Zapata has pointed out occasional frictions between himself and the older group. Like all Spaniards of his half generation, Zapata once relied upon Tàpies, Millares, Saura, Feito, and their companions as a conduit for foreign artistic ideas. His debt to Millares is even more precise, and more precisely acknowledged, since the manipulation of pieces of cloth in his procession series is so clearly related to Millares' techniques. In this respect, Zapata's house may be taken as a metaphor: the immense piers that anchor Millares' house to the hillside next to the Church of San Miguel in Cuenca also support Zapata's house. Similarly, Zapata's art may be said to rest on the foundation of the innovations of Millares and his contemporaries.

How may we compare Zapata's work to postwar art outside of Spain? Zapata has noted his admiration for Kline and Motherwell, and we need not repeat previous comments on the direct relationship between his gestural style and abstract expressionism. (Motherwell's works, many of which celebrate the Spanish Republic, were of course little exhibited in Franco's Spain.) In the late seventies, in conjunction with his manipulations of cloth, Zapata experimented with painting on mattresses and other techniques related to those of Robert Rauschenberg, whose works Zapata admires, and to the imagery of Edward Kienholz.

Many of Zapata's formal concerns find parallels in the works of other contemporary artists. The slashing, tearing quality of his gestures recalls similar elements in the works of Helen Frankenthaler and her followers. One is also reminded of the torn and cut paper tradition, so well expressed in the recent work of Ching Ho Cheng, whose works have an effect similar to Zapata's. Zapata's affirmation of gesture and use of thick modeled surfaces and stuck-on extrapictorial elements may be related to neoexpressionism and the work of artists like Julian Schnabel. Zapata, however, has come to eschew

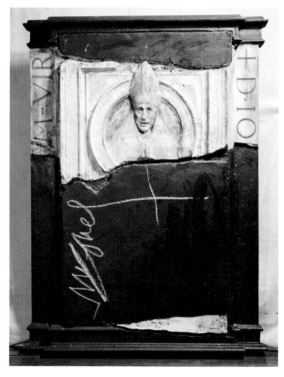

Figure 36. Untitled, checklist number 42, 1986 (053–86).

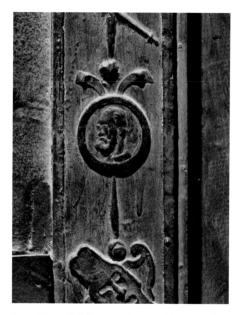

Figure 37. Detail of figure 38, showing self-portrait of Miguel Zapata.

expressionist means in the figural parts of his compositions, isolating gesture as pure form in the tradition of abstract expressionism.

The use of previous sculptural images, particularly funerary motifs, in architectural contexts is also found in the work of several contemporary artists, such as Cynthia Carlson (see the article by R. Upshaw in the Bibliography). Indeed, Zapata's compositions seem, at first glance, to have much in common with Carlson's recent "Monument Series" and her earlier architectural installations. Carlson's "Monuments," however, remain mimetic in method; they are large-scale drawings which imitate motifs visually rather than re-creating them as new autonomous works of art. (That is, she is

makes a drawing *of* something rather that making that thing over.) The sense of gesture in her coloristic interventions is much less forceful than in Zapata's works, and her relationship to the motif much more playful. Whereas Zapata reveres the artistic culture he relies on for imagery, Carlson (or at least, her works) takes a much less respectful stance.

Other contemporary artists, such as Anne and Patrick Poirier in France or Michele Stuart in the United States, have relied on a pseudo-archaeological metaphor in their works, creating extensive ruins or artifacts from civilizations that never existed. (A somewhat more abstract version of the same process may be found in the works of artists such as Gonzalo Fonseca.) There is of course an archaeo-

logical aspect to Zapata's works, but he does not fictionalize. Rather, he creates modern versions of well-known monuments from a civilization that did indeed exist and that continues to have an effect on the present age.

Like most postmodernist art, Zapata's works offer critiques of previous traditions. Zapata's refusal to surrender the nonfigurative quality of abstract expressionist gesture criticizes the current neoexpressionist wave, but Zapata, in effect, criticizes abstract expressionism — and most Spanish abstract art in the generation of Tàpies, Saura, and Millares — in his use of quotations from Renaissance art. His compositions also stand as a critique, if not a condemnation, of a society that allows the treasures of its past to fall into

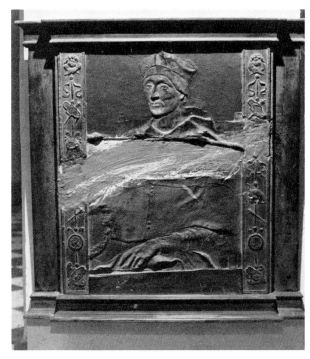

Figure 38. Untitled, checklist number 35, 1980–83 (045).

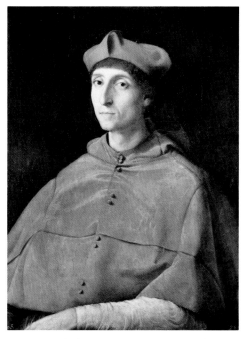

Figure 39. Raphael Sanzio (1483–1520), *Portrait of an Unknown Cardinal*; Prado Museum, Madrid (oil on panel).

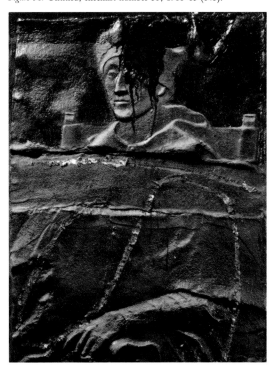

Figure 40. Untitled, checklist number 36, 1984 (037).

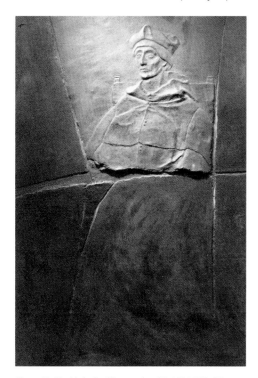

Figure 41. Untitled, checklist number 37, 1986 (040–86); color detail on front cover.

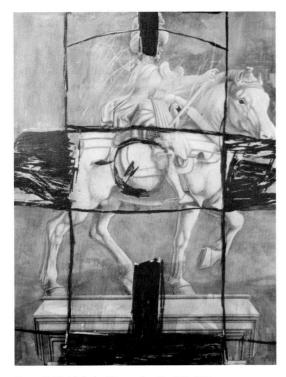

Figure 42. Untitled, checklist number 22, 1984 (022).

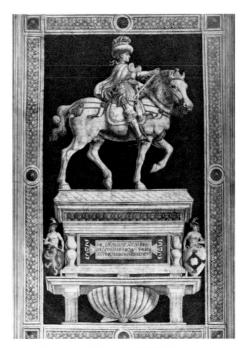

Figure 43. Andrea del Castagno (1417–57), *Equestrian Monument to Niccolò da Tolentino*, 1456; Florence Cathedral (fresco).

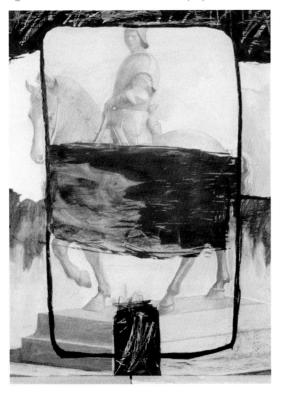

Figure 44. Untitled, checklist number 23, 1984 (023).

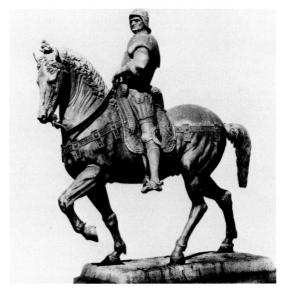

Figure 45. Andrea Verrocchio (1435–88), *Equestrian Monument to Bartolomeo Colleone*, 1480s; Campo dei SS. Giovanni e Paolo, Venice (bronze).

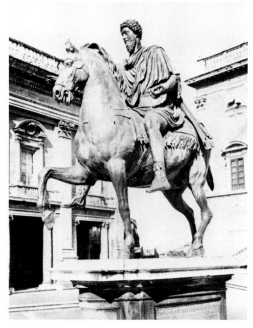

Figure 47. Anonymous Roman, *Equestrian Monument to Marcus Aurelius*; Capitoline Hill, Rome (bronze).

Figure 46. Untitled, checklist number 24, 1984 (024).

decay, or to be destroyed completely in the path of contemporary greed. Yet it is Zapata himself who attacks his versions of Renaissance monuments with consummate violence.

Obviously, Zapata's labors are born of respect, of love, of a desire to emulate the spirit of the Renaissance. As his agent, José Antonio García Tapia, has observed, Zapata's works respect the past in spite of attacking it. Indeed, Zapata's work shows respect for the past *because* it attacks in a modern, gestural way. Zapata has spoken of a desire to capture the resonances or echoes of a civilization that sought to revive ancient humanism in the context of Christian faith. But just as the Renaissance had to reinterpret the information it received about the ancient world in the

light of its own aesthetics, so must Zapata reinterpret his sources in the light of twentieth-century art. His emphasis on texture and *materia*, his bold colorism, even his gestural violence and his seeming desire to shatter and rip apart the older world he loves, are necessary in order to present the values of that world in the context of a culture that finds itself increasingly far away from the values of Donatello, Raphael, and El Greco. The artistic blows which Zapata strikes on the anvil of the Renaissance provide the energy necessary for us to hear the resonances, the distant echoes of another age.

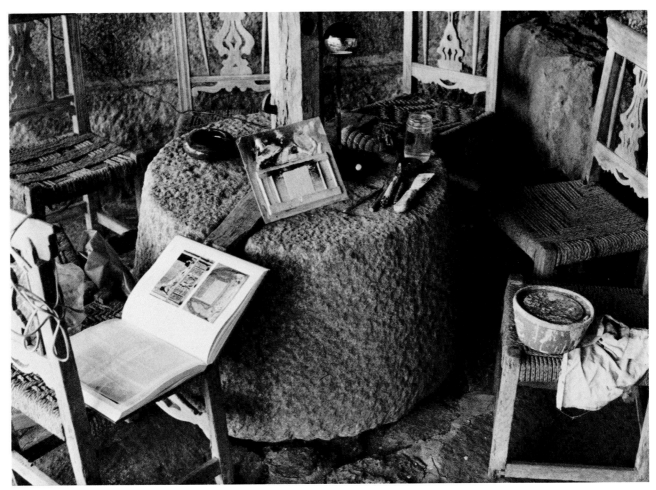

Figure 48. Zapata's temporary studio in an old mill on an
estate at Eiras, Galicia, Spain, June 1986.

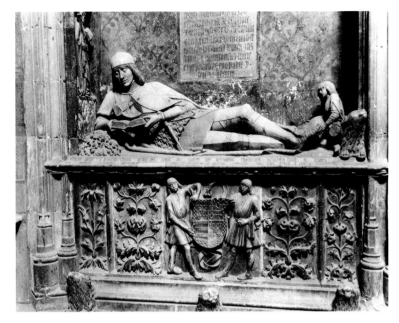

Figure 49. Anonymous Spanish, XV century, tomb of Don Martín Vázquez de Arca ("El Doncel"), Siguenza Cathedral.

Figure 50. Zapata's model after the Doncel tomb; work in progress, June 1986.

Figure 51. Miguel Zapata, Cuenca, June 1986.

A CONVERSATION WITH MIGUEL ZAPATA
Interview and Translation by Marcus Burke

The Department of Culture of the new Spanish autonomous region of Castilla–La Mancha recently presented a travelling exhibition of the works of Miguel Zapata in Albacete, Ciudad Real, Toledo, and Cuenca, where Zapata was born. I spent two weeks in Spain with Zapata, accompanying him as he transferred his works from Toledo to Cuenca. Zapata and I, along with his artistic representatives Begoña del Valle and José Antonio García Tapia, visited the exhibition on the last day of its Toledo installation in the partially restored church of a Dominican monastery which had been converted to secular use as a cultural center. After returning to Madrid for several days, we set out toward Cuenca, for what would turn out to be the triumphant return of a native son.

As we sped down a back road across the open plain of New Castile, passing through the province of Madrid into Castilla–La Mancha, Zapata would point out salient features and interesting sights. We might be approaching a noteworthy Gothic parish church in the next town. The farmers in one area had scratched vertical trenches down barren hillsides, manipulating erosion in order to wash nutrients onto the arable land below. A valley oasis was possessed of a village well with particularly sweet water. A detour took us to the fortress-monastery of Ucclés, the ancient headquarters of the Spanish military order of Santiago, with a Golden Age barrel-vaulted church, an eighteenth-century courtyard, and a mesmerizing plateresque façade from the epoch of Charles V. (This façade holds a special fascination for Zapata.)

The conversation was lively: cultural events, snatches of poetry from great works of Golden Age literature, bawdy flamenco tunes, and plainsong chants alternated with extended discourses on philosophy and politics. At times the discussion grew heated; there is much to debate in Spanish public life, including contemporary terrorism and the fading institutional horrors of the fascist past. At times, Begoña would gently change the subject, pointing out an agricultural development or commenting on what types of soil give rise to the best quail, which we could see starting from cover as the car passed. All three of my companions revealed themselves to be intellectuals in the best sense of the word, as well as veterans of many types of cultural activity.

As we neared Cuenca, the land began to rise. Pine forests replaced the parched wheat fields and broad agricultural valleys. The topography got rugged, as we entered the foothills of the massive mountain chain that separates the Castilian plains from the Mediterranean coast.

The old city of Cuenca perches on a peninsula carved out of the local mountains by two small rivers (figure 52). Bluffs hundreds of feet high form a natural fortress, on the side of which the famous Hanging Houses — multi-storied dwellings whose design goes back to the middle ages — cling, as it seems, precariously. It is the sort of place where history oozes out of cobblestone streets; where modern traffic has to be diverted around the city because several tour busses have already gone up the hill to the old town, exhausting its vehicle capacity; where an elderly lady, noticing my camera in the modern part of the city, urges us not to take pictures there but to go up to the old town, the real Cuenca. Although Zapata's exhibition would be in the headquarters of a local bank in the modern part of the city, this was only a temporary

inconvenience. Zapata's home and studio, his intellectual and social life, and, I suspect, his soul, are up on top of the bluff, on the old town square in front of a brooding cathedral, where the mayor can come to offer congratulations and fellow-artists can join the conversation over coffee and wine after a luncheon *al aire libre.*

The following conversation with Miguel Zapata began on that square in Cuenca and continued over the course of ten days and much of the map of Spain. I found his comments on life and art extremely illuminating, not only as aids to the appreciation of his works but also as an aesthetic philosophy and a guide for other artists, especially young artists coming of age at the end of an artistic era.

The paragraphs below in *italics* represent Marcus Burke's questions; those in Roman type represent Zapata's replies and comments.

There has been a tremendous interest in the American press, including art publications, over la movida, *the new artistic ferment in contemporary Spain. Given the success of your recent gallery exhibitions in Madrid, and the retrospective exhibition that has been touring Castilla–La Mancha, you seem to be very much a part of the new artistic scene. How do you feel about what's going on in the Spanish art world?*

I don't really think of myself as part of the so-called *movida.* I often think *la movida* is more a matter of publicity — to sell fashion and furniture and get Spain in the international press — than something that affects serious art.

But you are obviously stimulated by the new possibilities of expression — of artistic communication — in today's Spain.

Communication has long been a classical theme in art theory, and I believe very strongly and clearly that art is a means of expression, just like the tongue in which I am talking to you. But as a means of expression, art has to have an interior syntax, an absolutely formal interior structure. It has to have a verb, a subject, and their complements.

How does one find this structure in the visual arts?

By seeking the same exactitude — the subject, the predicate, etc. I know laws exist that allow a work of art to be balanced. There are symmetries, resonances, internal equilibria, that allow the work of art — when it is well made — to be structured by the rules of a higher order, something that transcends the work of art itself and is, to some small extent, an approximation of the ideas of divinity and cosmic equilibrium.

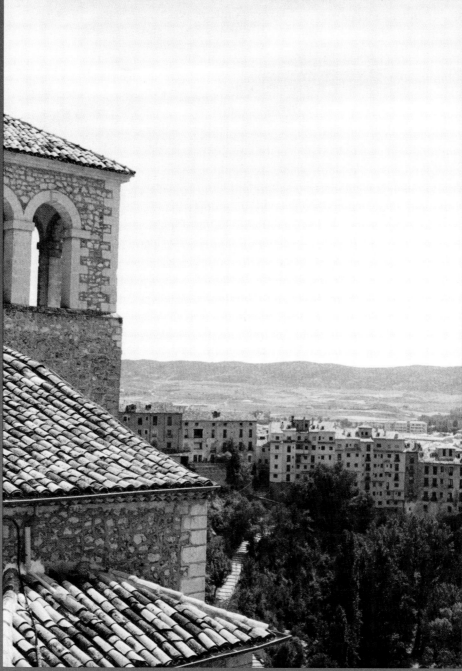

Figure 52. View to the southwest from Miguel Zapata's house in Cuenca. The building to the left is the parish church of San Miguel; a group of *casas colgadas* may be seen across the ravine.

This sounds like a hymn of praise for modern design. Is direct communication via abstract design all there is to art?

There are extremely beautiful voices capable of singing the most marvelous texts, but the owners of the voices can't read the script and they don't even know how to use the voices. Consequently there is often a squandering of cries coming out of prodigious throats, but without articulating words, without communicating anything, because they don't know anything. This might also be the case with certain painters in *la movida*.

But the argument of Modernism is that the voice itself, even if it doesn't understand the words, can be significant.

I have heard this said, but it reduces to a minimum the artistic possibilities that could be at the maximum. It is not only, as we say in Spanish, that the good is the bad of the best, but also that even these minimal possibilities exhaust themselves at the very moment they are emitted. And this is to analyze things from an utterly generous point of view, because if you follow this line of reasoning to its conclusion, you come to a point where the reduction of possibilities leads to absolute gratuitousness — where the artistic act loses all justification for its existence.

And what do you consider sufficient justification for art?

I find no justification in my artistic work unless I am able to endow it with an ethical dimension. And this ethical significance has to ally itself with a search for transcendent knowledge.

So you view the artistic act as something closely allied with philosophy?

Yes. My work, for me, constitutes a path to Knowledge, and it happens that all paths to Knowledge — that is, Knowledge as wisdom, Knowledge with a capital "K", which is synonymous with divinity — serve to bring us nearer to the divine. I think my work finds its authentic significance in its ethical orientation, for this ethical dimension transcends the work and sets it onto a path of Knowledge that enriches me and brings me to a self-realization, since the more I know, the more I am.

Does that mean you are happy with the way philosophy has served men and women in their search for this Knowledge?

According to philosophy, there are various routes that one can take to Knowledge, such as ethics, aesthetics, psychology, logic, etc. But ever since Aristotle, logic has exercised a tyrranical dictatorship over our culture, a dictatorship that reduces any other attempt to approach learning to a type of madness or stupidity.

And you are dissatisfied with this enforced reductio ad absurdum?

I assert the right to be a man who is endowed with more of a gift for aesthetics and ethics than for logic.

Since your involvement with art has been a lifelong endeavor, why have so many recent reviews treated you as a new or emerging artist?

Because I appeared on the contemporary Spanish art scene after having totally left the world of art for something like twelve years. When I returned to Cuenca, I did so for absolutely different reasons, political reasons, and only later returned to making art.

I find it interesting that, on the one hand, you are able to articulate a systematic, profound, intricate philosophy, but on the other hand, you seem, as an artist, very little obsessed with theory.

In my heart of hearts, I believe that everything I say in conversations such as this is true, but at the same time, nothing is. Because I also believe that theory has never preceded practice. Nevertheless, it is necessary, in interviews or conversations such as this, to give doctrinal responses to what has been, quite simply, a product of intuition, of chance, or of circumstance.

When you work honestly, it is normal to encounter things by chance that, together with other things you are going to encounter, lead to the creation of a means of making art. Picasso said, "I don't seek; I encounter."

I believe that, in all cases, if one is going to claim any merit for oneself, it would be the humble task of keeping the machinery well oiled.

That is to say, keeping your artistic facilities sharp.

Yes. So that when an Idea comes along — an Idea that is not mine, that is floating, that passes over me as if in a séance, as if over (I don't know who said it) a person who is asleep — and crashes into me, I will be nimble enough to translate it into forms or colors.

In the way that it is the duty of a photographer always to have his or her camera ready?

Yes, but he does not provoke the event, nor is he guilty of what occurs in front of him. But he is always, always awake, ready to catch the event.

Let's return to the idea of your artistic work as a search. You have said that the ethical dimension has to be allied with a search for Knowledge, which can, in effect, transcend, bring one closer to the divine — closer, in fact, to God. But I have also heard you say that this search is, at the same time, a matter of self-realization, largely an affirmation of the self. Isn't there a conflict between affirming the self and seeking God?

Let me explain. When I speak of transcending the physical limits of the artistic act by means of an ethical dimension, I am referring to the untiring way in which nature re-creates itself, to the unfinished character of the world. In this context, the authentic work of art appears as a necessary event, made possible in turn by an understanding integrated into the nature of things. The artistic act must enter into a resonance with higher structures of existence, which exceed the limited physical dimensions of the work of art. This understanding can only be attained by following a series of conditions of an ethical character, which lead the artist who follows them along indispensible paths of virtue, to the end of obtaining the gift of divining the dimensions of that which is imminent.

So this road to perfection is a way of drawing near to the concept of wisdom — of divinity — and at the same time an enrichment of the self.

Where do you find inspiration for your own search?

There is a type of humble and meticulous craftsmanship that we see on the jambs and lintels of plateresque façades, or in the interiors of great cathedrals, which was not done simply to adorn but as a type of prayer — it serves as an authentic prayer (figure 53). In these works the most minute perfection corresponds to

32

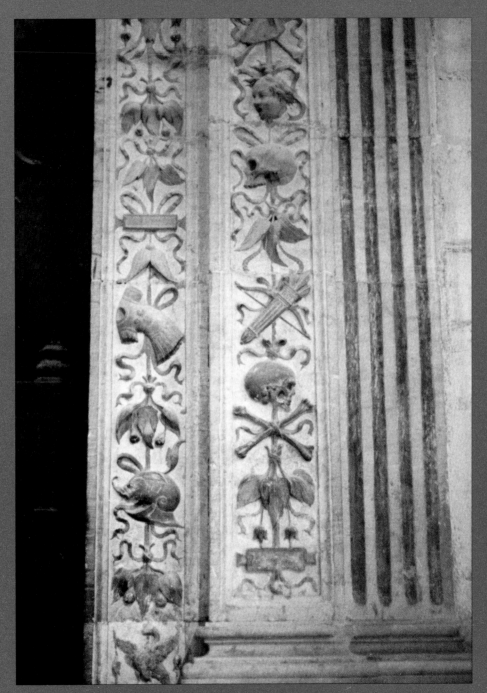

Figure 53. Ascribed to Antonio Flores, carving on a lintel
of the Knights' Portal, Cuenca Cathedral (detail); see
figure 21.

the greatest proximity to or possibility of Knowledge, so that the better made the work of art, the better the "prayer" rising from it. In fact, we might even go so far as to equate this divine Knowledge with artistic technique developed as the fruit of many hours of meditation, and to say that a lack of technique implies an absence of any sense of transcendence, since the one is the means by which the other is expressed. Only a correct and patient understanding can stimulate the appearance of the Idea in a work of art.

This helps explain your attraction to Renaissance monuments, and the use of them in your work. In the Renaissance, an artist's technical preparation entailed an apprenticeship of many years, stimulated — if we are to believe the literary sources — by religious as well as other motives, all with the goal of preparing well for a career of art.

Preparing technically and preparing religiously are all part of the same thing, but today we don't spend twenty or thirty years in the workshop learning it. There is a magnificent picture, a painting by Verrochio in which St. John is baptizing Jesus. And to the side there is a little angel painted by an advanced pupil who had already worked for many years until finally the master let him collaborate. You know that the pupil was called Leonardo de Vinci. If this great man found it necessary to work in such a way, I must doubt the ability of a young person today, who has no studies and no idea of what God is, to improvise in the face of concepts that are for him, at best, the remains of a demolition.

You obviously don't share any such handicap. In fact, I'm amazed at your store of knowledge and images from earlier art. But which Renaissance artists are particularly important for you? Your works use motifs from Raphael, El Greco, Donatello — and you have told me that Donatello carries particular significance for you.

More than particular artists, what interests me is the idea of the Renaissance: the attitude of humanistic affirmation and the application of reason by means of canons, or standard norms. The aspect of the Renaissance that I work on is based more on the whole, the complete picture of the Renaissance, than on its individual protagonists.

On the visual culture of the Renaissance as an idea in itself?

In effect — but what is more, considering that the Renaissance's references to the ancient classical world have to be taken with considerable reservations, with the understanding that the people of the Renaissance were to the ancients and to classical culture what I am to the Renaissance. That is, a distant resonance, an echo, to which you revert when you see tympani, pediments, or columns, but which cannot be compared directly to the authentic canons. The ancients would never have placed a Doric column on top of a raised edge that is itself supported by a base — which we see in various Renaissance monuments, among other absolutely gratuitous interpretations of the ancient canons.

Not to mention having used architectural elements salvaged from the ruins of ancient buildings.

Yes. Including the remains that were used.

But to return to your initial idea: you do not speak of specific artists but of the effect of a period in its entirety.

Of the smell, of the aroma that suggests the classical world; the spirit of the age. Of course, among the artists of the Renaissance there are those who suggest more to me than others. It's a matter of what gets under your skin. For example, the *St. George* of Donatello was in my schoolbooks. It was extremely beautiful, and I remember how much true pleasure it gave me as a child, and how I often drew it. And later, in Florence, I saw works by Donatello that impressed me tremendously.

Is what you do with your historical sources different from the widespread use of older art in contemporary compositions? For example, how is your work distinct from the art of, say, Francis Bacon?

There is obviously a relationship between my art and his, but in fact the two are very different. My work is distinct formally and technically, as in my incorporation of extrapictorial elements in my works. But what is more, the transformation that Bacon works, for example, on Velázquez's *Innocent X* is, to put it simply, a malleable, painterly readaptation of the sitter's image in surrealist terms.

My art, in contrast, deals with resonances. The idea is to establish a dialogue between a world of *a priori* visual arrays (*ordenaciones*) and a world of gestures. And within this world of arrays, the one that is closest to me is the Renaissance.

Instead of the world of the Greeks?

I live on the other side of the Mediterranean, and I find myself very far away from classical Greece. And the Spanish Renaissance is already Christian, with a strong charge of Christian values.

And therefore closer in spirit.

Clearly. It is very close, it is here in my own land, so that I can get information *in situ*.

This world must have entered your life very early.

I was always drawing, and always playing in the cathedral (figure 54).

You actually played as a child in the Cuenca Cathedral?

Yes, with other children. We would run through the nave and aisles there and hide in the chapels; and the priests would come and throw us out. My old school was just below the cathedral.

You seem very attached to this region.

Driving here from Madrid, I noticed how closely the scratches I gouge into the relief on some of my works resemble the trenches that the local farmers carve into hillsides.

I was particularly impressed by our visit to Ucclés.

Wouldn't it be wonderful if one could reproduce those marvelous window frames and pediments — all that wonderful carving — by taking a mold and casting acrylic replicas for some great museum, so that it would not be lost, so that it could be enjoyed.

The destruction of Spain's artistic heritage has been terrible. Just here in Castilla–La Mancha alone, there has been great loss

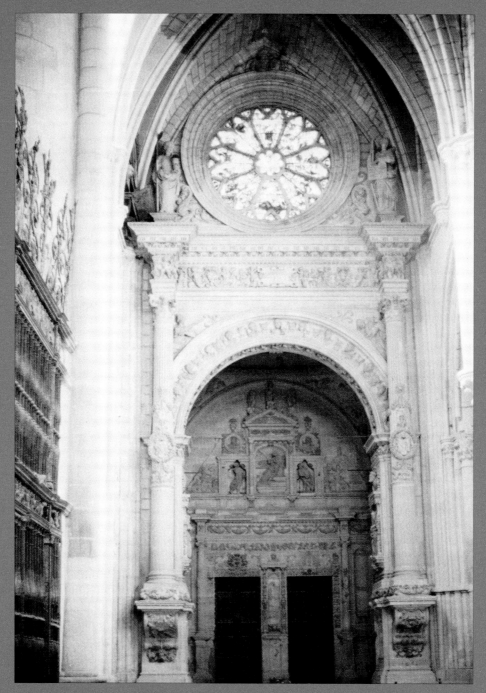

Figure 54. The crossing of Cuenca Cathedral.

— Guadalajara, Ciudad Real. Imagine a town like Ciudad Real, almost completely destroyed by modern building. It is one thing to tear down a building in Dallas, a city with only a hundred years of history, where all the architecture has got to be a little bit ephemeral, a little bit tentative, but to destroy twelve hundred years of civilization — twelve hundred years! That is a crime.

I was looking at one of your scenes of Holy Week in Cuenca, in which a procession moves along the street carrying a float with religious sculpture on it; in your composition, of course, the float is represented abstractly by blocks of wood. One of your childhood playmates was standing with me and was quite amazed by the image. He explained that in Cuenca, groups of children make imitations of the large religious floats out of scrap lumber and actually parade them through the streets. In effect, he interpreted the composition as an evocation of a childhood experience.

Although I often saw groups of children pretending to carry *pasos* through the streets, I never participated in building one of the floats myself. My images are abstractions. But of course, I experienced and often participated in many of the official processions moving through the streets of Cuenca.

Once, at an exhibition of my works, I asked a group of children, "What is that?" And they replied, "A procession." The image was made up of scraps of old pants, of the rags that I wiped my brushes on, all glued together. There were no figures, absolutely nothing of a representational nature, but the children recognized the image. It was partly because they were so impregnated with the customs of Cuenca, they had received such a strong dose of tradition. And they could have been from any small town in Spain where the old traditions are still alive — but of course, not from Madrid anymore.

But I have heard you say that there is another reason the children recognized the image.

Yes. It has to do with the architecture. When I first began working on the procession series, I was absorbed in the problems of manipulating the materials. I found that when I wanted to express a multitude or a procession — when I wanted to achieve an anecdotal quality of popular religious events or of images remembered from my childhood, when I participated in the processions — it was not enough simply to manipulate the painted rags and scraps of cloth. They remained manipulated scraps unless they were placed in front of an arch or doorway. But once that was done, you recognized the scraps of cloth as people.

A gestalt image: the architectural ground provided a context against which it was easier to equate the abstract forms of the rags with human figures.

Yes.

You speak of art as a means of approaching a divine Knowledge, and you feel that the meticulous art of the Renaissance is particularly well adapted to the search for Knowledge, as a type of artistic prayer, even. But your own art is not a mere re-creation of Renaissance style; it is very modern, especially with regard to the tradition of abstract gestural art found in Kline and Saura. How can this art of large-scale gestures serve to bring us closer to the Knowledge you speak of?

Great gesture is equally the fruit of long preparation; the attitude of the artist will be the same as with Renaissance craftsmanship, as will the ethical conditions that are necessary to motivate him. We were speaking earlier of delicate and detailed work; now we're referring to the stroke, at once violent and rich in artistic means (*materia*), that divides, forces its way through, or splatters the picture plane. But violent or not, this gesture is studied repeatedly by the artist. The Orientals — especially the Zen culture — speak of a gesture repeated throughout an entire lifetime until the artist is able to execute it with dexterity.

A gesture prepared for in advance?

A gesture that tears a thousand sheets of rice paper, until it comes out right. It is a labor of concentration, of religion, of introspection, of attempting simultaneity of thought and action.

Then it is possible to find significance in gesture, because it has been prepared by the experience of a lifetime.

Clearly. And because it has its place within the interior structure and syntax of the work. When you come across a gestural work by Kline, for example, if the painting has been done well, the gesture will be in its place in the design, exactly in its place.

I know that for you, drawing is an extremely important part of your preparation.

I am specializing in a type of drawing that requires no gesture, that doesn't demand a synthesis. I am making a very meticulous, very functional type of drawing, that contrasts with the brutal gestures I am going to apply on top of the work. The more meticulous, the more detailed, the more finely drawn — the less spontaneous — the strokes are in the drawing, the more effective will be the forms I put on top of the image. Only a man who knows how to draw can know how to put the gesture in the right place.

But it is a terrible process. Most dangerous, especially in the type of work I do. You have drawn, painted, modeled a thing with all your power. And then you throw a gesture over the top of it which, if it isn't done well, will destroy everything. In order for the gesture to be effective, it has to be in its place, and you have to have practiced it over and over again.

CHRONOLOGY

1940 Miguel Zapata is born in Cuenca, Spain.

1958 Wins a commission to decorate the cupola of the parish church of La Merced in Huete; wins the Sesamo prize, a national competition, for painting.

1959 Exhibition at the Machetti Gallery, Cuenca.

1960 Exhibition at the Municipal Art Gallery, San Sebastian.

1961 Resides in Barcelona; participates in collective exhibition of contemporary art, Viceregal Palace, Barcelona.

1962 Exhibitions at the University of Salamanca and in the exhibition hall of the National Savings Bank, Valladolid.

1963 Exhibitions at the Librería Abril Gallery, Madrid, and the Illescas Gallery, Bilbao. Also produces graphic works, book designs (Aguilar Publishers), and theater sets (Teatro Español, Madrid, in collaboration with Victor María Cortezo).

1964–67 Lives in Paris; works as a set and costume designer and stage technician for the independent Spanish theater group La Carraca at the Theatre Aux Trois Baudes; travels with group and independently throughout Europe, North Africa, and the United States.

1967–72 Zapata returns to Madrid, living initially with his parents. Friendship with the physician-collector Antonio Requena stimulates Zapata to begin painting again and to enter medical school; assists in anatomy classes. Political involvement leads to expulsion from university.

1972 Returns to Cuenca; acquires a house above that of the Spanish abstract artist, Manuel Millares (1926–1972).

1979 Exhibition at the National Savings Bank, Cuenca. Provides designs for a group of buildings, the Puerta de San Juan, in the Cuenca historical district. Collaborates in courses on analysis of forms at the School of Architecture, University of Madrid. Exhibition at Juana Mordó Gallery, Madrid.

1981 Exhibition at the El Mirador Gallery, Cuenca.

1982 Designs and directs the remodeling and integration of the façades of buildings used by the Provincial Museum of Cuenca, under commission from the Spanish Ministry of Culture. Designs poster for the international tour of Angel Facio's production of La Celestina (Teatro del Aire, Madrid).

1983 Exhibitions at the Juana Mordó Gallery, Madrid, and the Arteder 83 art fair, Bilbao.

1984 Exhibitions at the Arco 84 art fair, Madrid; the Provincial Museum (Casa de los Caballos), Cáceres; and the Carmen Benedet Gallery, Oviedo.

1985 Exhibitions at the Casa Lis, Salamanca; the Museum of Contemporary Art, Caceres; and the Biosca Gallery, Madrid.

1986 Exhibition at the Arco 86 art fair, Madrid. Travelling exhibition organized by the Department of Education and Culture of the new autonomous region (*Comunidad*) of Castilla–La Mancha; exhibition is presented in Albacete, Ciudad Real, Toledo, and Cuenca.

All of the works in the exhibition are untitled; the descriptive phrases in parentheses are for identification only. Five-figure catalogue numbers in parentheses refer to the general inventory of Zapata's works being prepared by José Antonio García Tapia, Madrid.

Dimensions are in centimeters, height before width; unless otherwise specified, works are the property of the artist.

I. Processions and figures in painted cloth and mixed media, 1975–78.

1. Untitled (Pietà from Eiras), 1975 (003–75)
 132 x 115; O Pepito Collection (Señores de Gándara), Spain.

2. Untitled (Procession in Cuenca), 1975
 (001–75)166 x 128; Manuel Noeda Collection, Madrid.
 Figure 2.

3. Untitled (Procession), 1975
 (047–75)128 x 159; Cuenca Museum.

4. Untitled (Procession), 1976 (005–76)
 86 x 95; Begoña del Valle Collection, Madrid.

5. Untitled (Yellow Procession), 1976
 (006–76)167 x 103. Figure 3.

6. Untitled (Estanco Procession), 1975–78 (009–78)
 162 x 154. Figure 4.

7. Untitled (Procession), 1978 (015–78)
 160 x 145; private collection, Spain. Figure 7.

8. Untitled (Bishop), 1978 (007–78)
 162 x 100; O Pepito Collection. Figure 5.

9. Untitled (Bishop), 1978 (008–78)
 162 x 100; Antonio Requena Collection, Madrid.

II. Painted figural reliefs, 1982–85. Mixed media on hardened papier mâché, plaster, or other supports.

10. Untitled (Pietà), after Vázquez and Michelangelo, 1982
 (016–82); 3 pieces, 176 x 228. Figure 8.

11. Untitled (Battle Mural), after Michelangelo, 1983–85 (017)
 16 pieces, 240 x 250. Figure 10.

12. Untitled (Warriors), 1980–83 (014–83)
 162 x 142. Figure 12.

III. Architectural motifs, mixed media principally on a base of formed paper.

13. Untitled (Hospice Door), 1983 (012–83)
 210 x 140. Figure 13.

14. Untitled (Portada Fabulam), 1983–84 (021)
167 x 138. Figure 14.

Three untitled works based on a window of the Chapel of the Apostles, Cuenca Cathedral; 80 x 62:

15. 1982 (052–82). Figure 17.

16. 1983 (030–83); Concha Gregori Collection, Madrid.
Figure 18.

17. 1984 (028–84). Figure 19.

18. Untitled (Knights' Portal in Green), 1983 (013–83)160 x 140; Gloria Giménez Collection, Spain. Figure 20.

IV. **Large-scale drawings after architectural and equestrian subjects; mixed graphic media on paper.**

Untitled, based on the Knights' Portal, Cuenca Cathedral; 131 x 101:

19. In red ochre, 1984 (033–84).
Illustrated on back cover.

20. In yellow, 1984 (034–84).
Illustrated on back cover.

21. In white, 1986 (035–86).

Equestrian figures; 134 x 103:

22. Untitled (Niccolò da Tolentino in green), after Castagno, 1984 (022). Figure 42.

23. Untitled (Colleone), after Verrocchio, 1984 (023).
Figure 44.

24. Untitled (Marcus Aurelius), 1984 (024). Figure 46.

V. **Figural variations on Renaissance prototypes; mixed media, principally on a base of formed paper.**

"Paravicino" series, after El Greco:

25. Untitled (Paravicino), 1983 (038–83)
56 x 60; Collection of Eduardo Aznar, Madrid.
Figure 27.

26. Untitled (Paravicino), 1983 (011–83)
179 x 163; Adrian Slotemaker Collection, Madrid.
Figure 28.

27. Untitled (Paravicino in white), 1985 (019–85)
162 x 112.

28. Untitled (Paravicino in red), 1985 (020–85)
162 x 112. Figure 29.

"Inquisitor Corro" series, after Vázquez:

29. With automobile hood, 1983 (056), 160 x 140; Antón Gastón Collection, Madrid. Figure 31.

30. 1984 (018–84), 134 x 162.

31. 1981/83 (039–83), 56 x 60 (inset 20 x 26); Amaya Aznar Collection, Madrid. Figure 32.

32. 1984 (064), 56 x 60 (inset 20 x 26). Figure 33.

33. With license plate, 1984 (044–84), 56 x 60 (inset 20 x 26); Ceferino Yáñez Collection, Madrid. Figure 34.

34. 1984 (036–84), 56 x 60 (inset 20 x 26); Bernardo García Tapia Collection, Madrid. Figure 35.

"Cardinal" series, after Raphael:

35. 1980–83 (045), 102 x 102; Marian Hiero Collection, Spain. Figures 38 and 39 (detail, showing self–portrait of Miguel Zapata).

36. 1984 (037), 80 x 62; Luis Pinto–Coelho Collection, Spain. Figure 40; detail illustrated opposite the foreword.

37. 1986 (040–86), 162 x 112. Figure 41; detail illustrated in color on front cover.

VI. **Figural reliefs, after various Renaissance prototypes; mixed media, principally on a base of formed paper.**

38. Untitled (Cardinal with Skullcap), 1985 (067–85) 49 x 32. Figure 22.

39. Untitled ("Bird" Bishop), 1986 (025–86) 80 x 62 (inset 68 x 50). Figure 23.

40. Untitled (Readers), after Huguet, 1986 (054–86) 80 x 62 (inset 68 x 50). Figure 24.

41. Untitled (Black Frieze), 1986 (042–86) 103 x 83.5 .

42. Untitled (Bishop from Astorga Cathedral), 1986 (053–86) 121 x 92. Figure 36; detail illustrated on frontispiece.

[Note: the face of the figure is based on Donatello's *Zuccone* for the Florence Campanile (now Museo dell'Opera del Duomo; not illustrated).]

43. Untitled (Knight), 1986 (060–86) 205 x 120.

44. Untitled (Pope Innocent X), after Velázquez, 1986 160 x 150.

Areán, Carlos. *La Pintura Expresionista en España*. Madrid: Ibérico Europea de Ediciones, S.A., 1984.

Calvo Serraller, Francisco. Introduction to catalogue of Miguel Zapata's exhibition, Museo de Arte Contemporaneo de Cáceres, 1985.

Castro Arines, José de. Introduction to catalogue of Miguel Zapata's exhibition, Juana Mordó Gallery, Madrid, 1983.

Franca, José-Augusto. *Millares*. Barcelona: Ediciones Polígrafa, S.A., n.d. [1977].

Gaya Nuño, Juan Antonio. *La Pintura Española del Siglo XX*. Madrid: Ibérico Europea de Ediciones, S.A., n.d. [1970].

Pérez-Guerra, José. Review of Miguel Zapata's exhibition at Biosca Gallery, Madrid, in *Cinco Días*, 3 January 1986.

Pirovano, Carlo. *Burri*. Milan: Arnoldo Mondadori Editore, 1984.

Selz, Peter. *Art in Our Times*. New York: Harry N. Abrams, Inc., 1981.

Sullivan, Edward J. "Structure and Tradition in Some New Images from Spain." *Arts Magazine,* June 1980, pp. 142-45.

Upshaw, Reagan. "Cynthia Carlson: Memento Mori." *Art in America*, July 1986, pp. 108-111.

Schiff, Gert. "Torn Together: Ching Ho Cheng's unrepeatable abstractions." *Artforum*, January 1986, pp. 82-85.